★

101 Ways to
Read a Book

101

WAYS TO

READ
A BOOK

Timothée de Fombelle

ILLUSTRATED BY
Benjamin Chaud

TRANSLATED BY
Karin Snelson & Angus Yuen-Killick

RED COMET PRESS · BROOKLYN

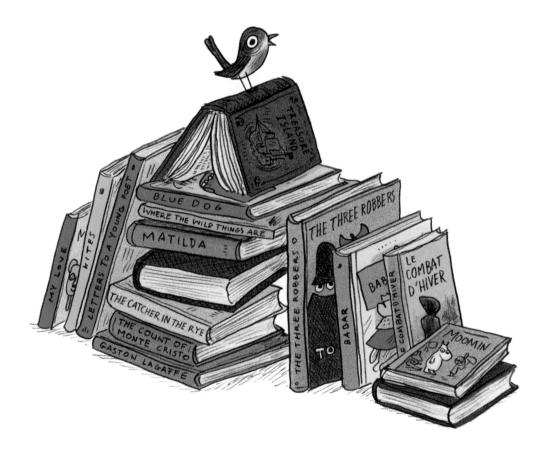

WARNING

Within these pages you'll find a carefully curated collection of observations . . . specifically, 101 ways to read a book. The illustrations document the varied, and sometimes unpredictable, effects of reading on human beings. However, it should be noted that certain featured poses should only be attempted by adults under the close supervision of a child.

The Sunflower
seeks out the light

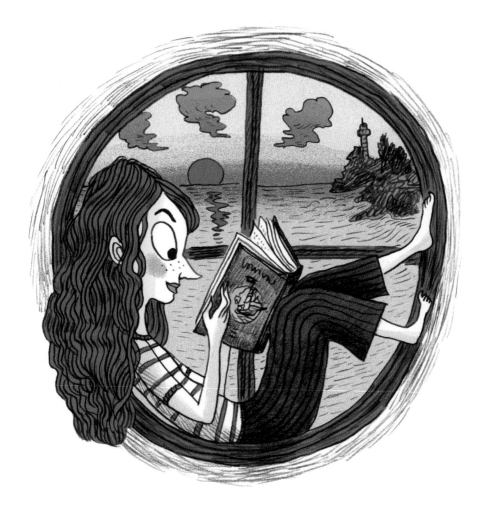

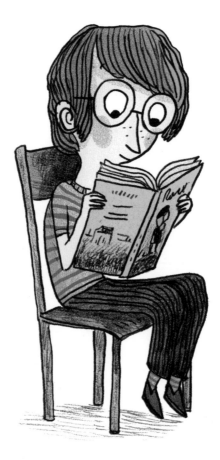

The Classic
is surprisingly rare

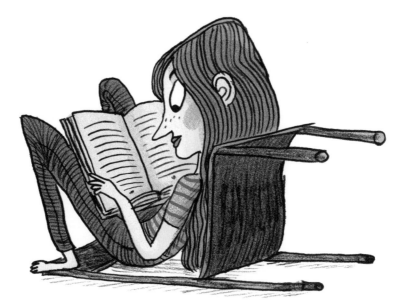

The Innovator
upends the norm

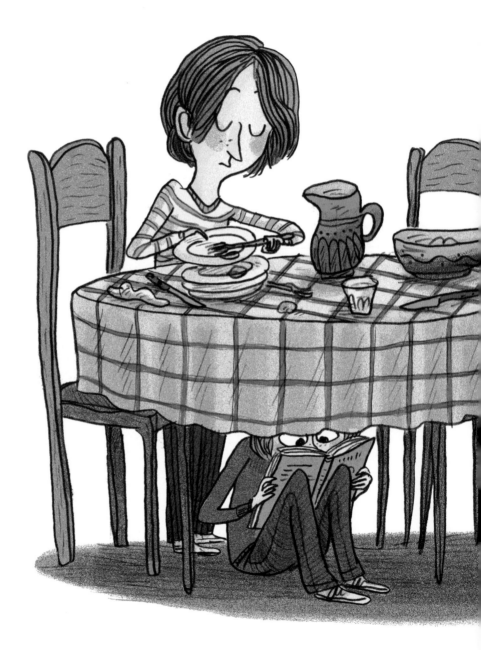

The Chihuahua becomes tiny
when necessary

The Diva
gives and gives

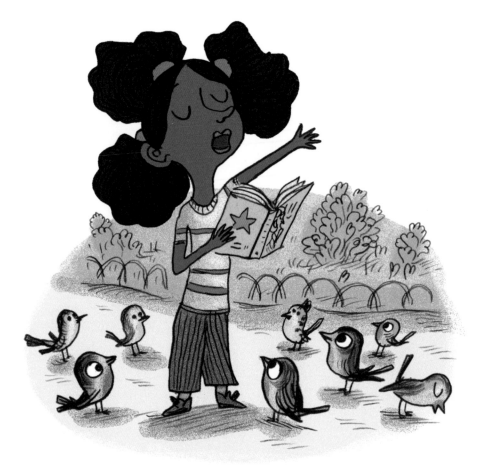

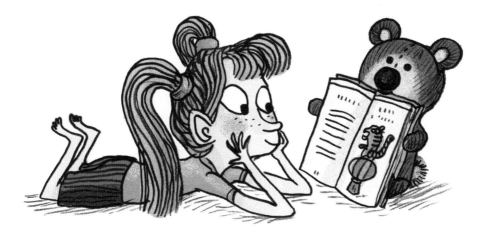

The Animal Trainer
values teamwork

The Riveted
keeps going until "The End"

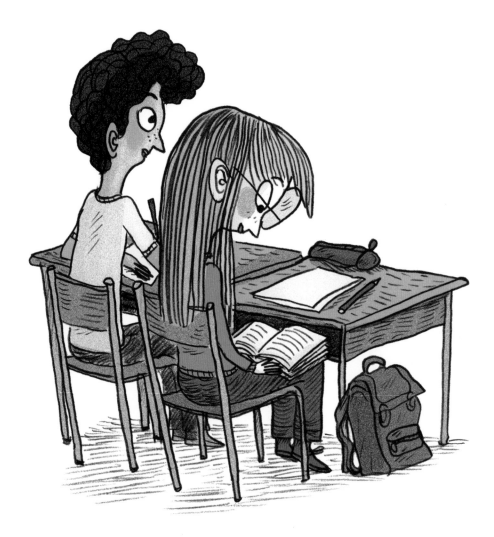

The Wildflower
opens in the springtime

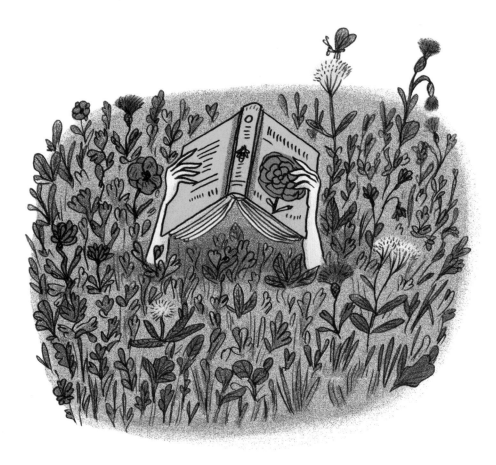

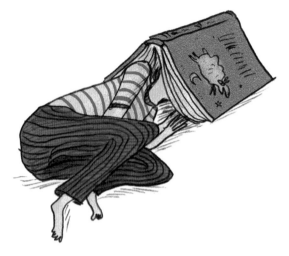

The Bookmark

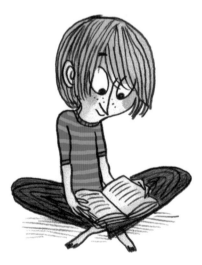

The Lotus

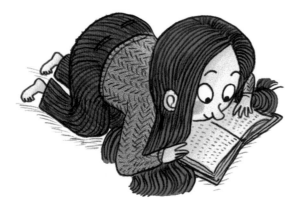

The Bubble

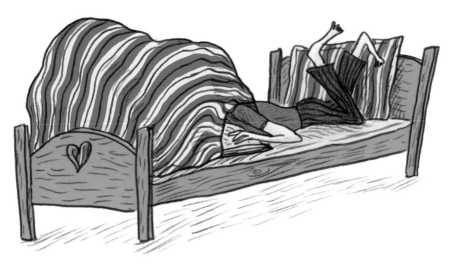

The Ostrich

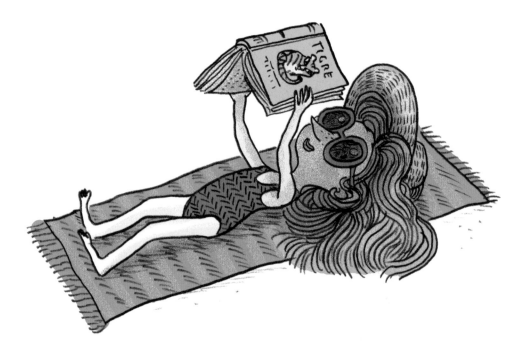

The Parasol
can bask for hours

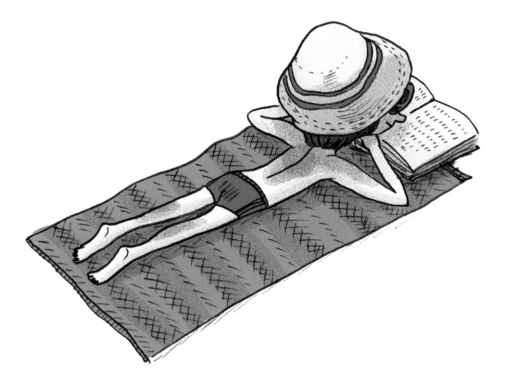

The Lobster
is almost cooked

The Sleepwalker
lives dangerously

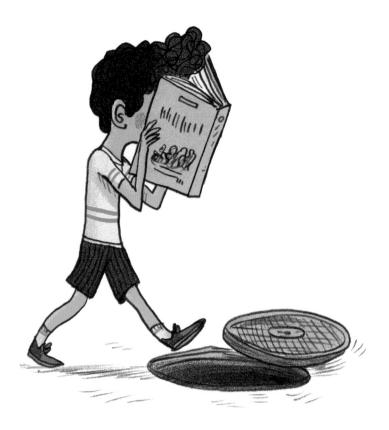

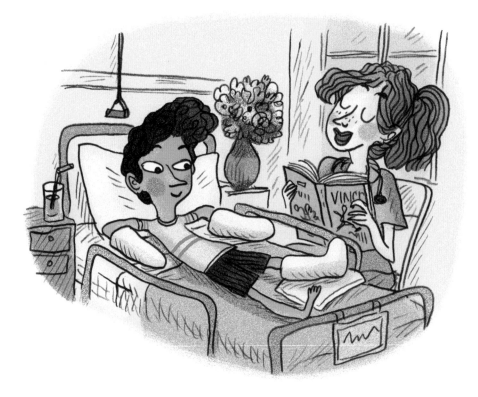

The Indestructible
bounces back

The Octopus
doesn't need to choose

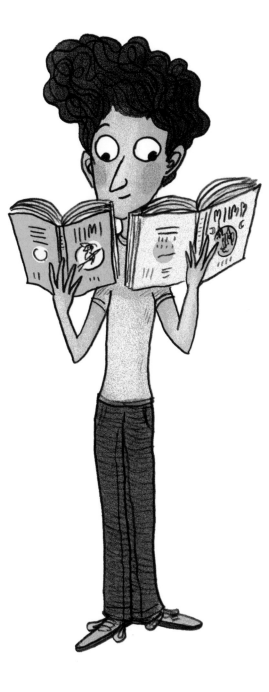

The Romantic

can weather any storm

The Champion
takes on the heavyweight

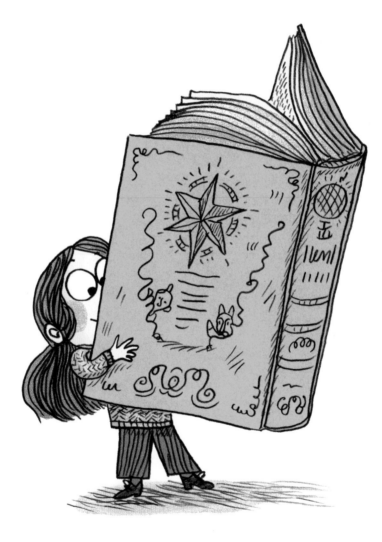

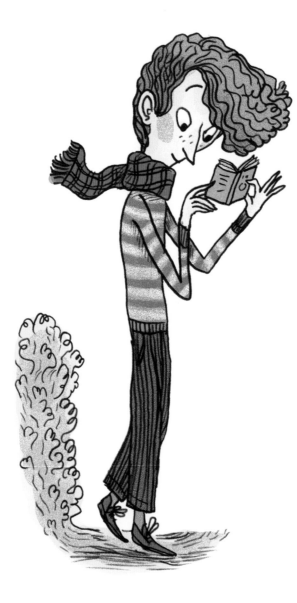

The Wisp
travels light

The Pragmatist
is prepared for any emergency

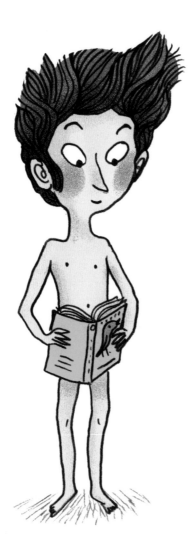

The Main Course

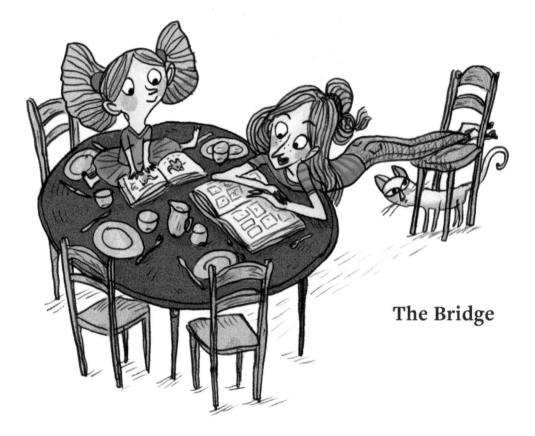

The Bridge

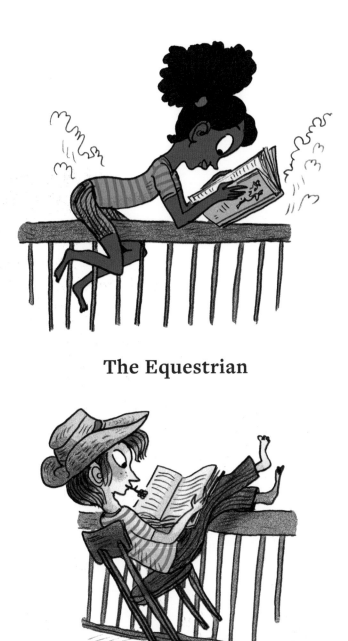

The Equestrian

The Cowpoke

The Leashed Dog
is trusting

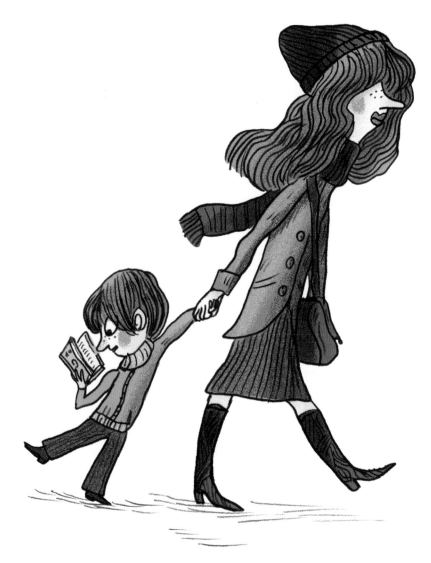

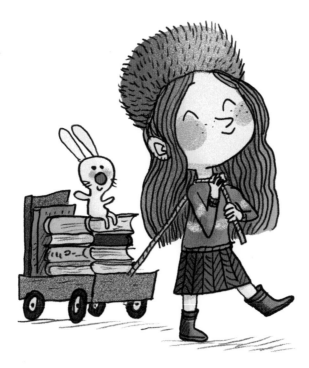

The Sled Dog
prefers long winters

The Snowman

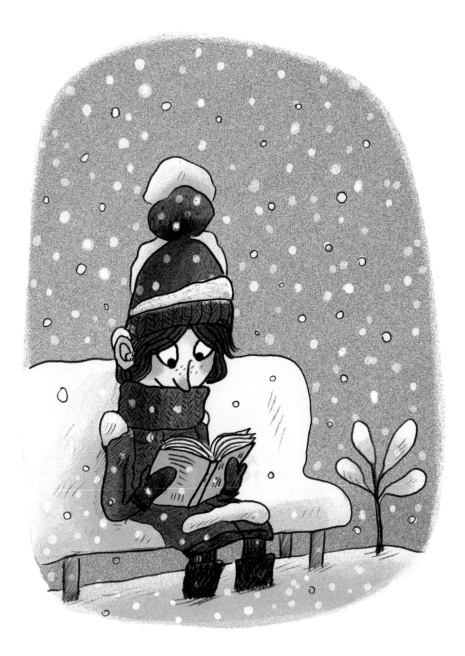

The Drifter

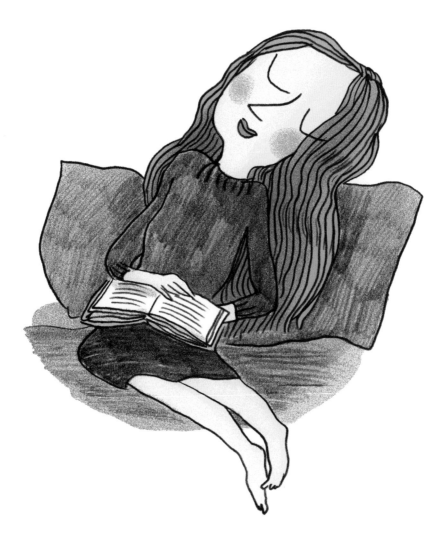

The Eye of the Storm

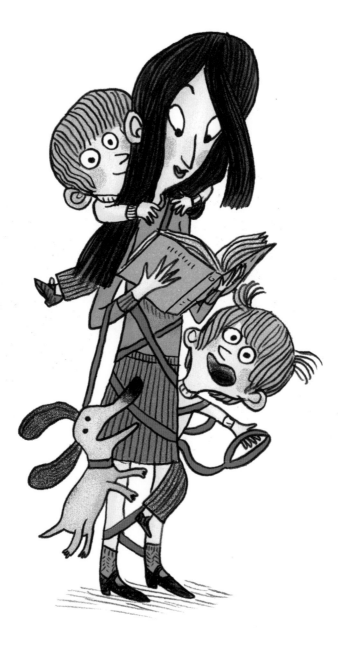

The Connoisseur
politely declines dessert

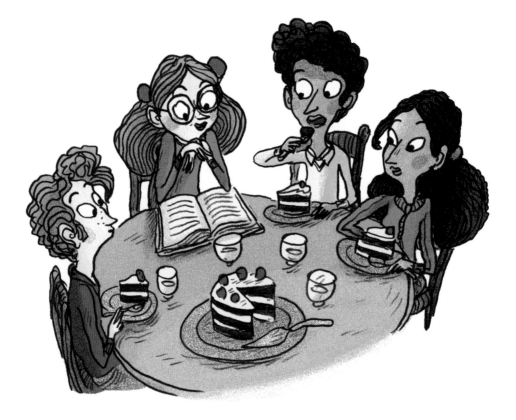

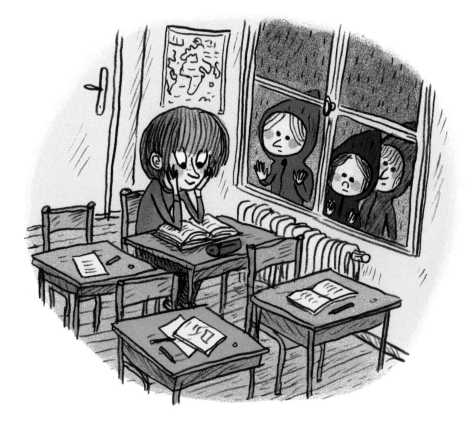

The Happy Hermit
stays warm and dry

The Lovebirds
are inseparable

The Ruminants
graze on more than grass

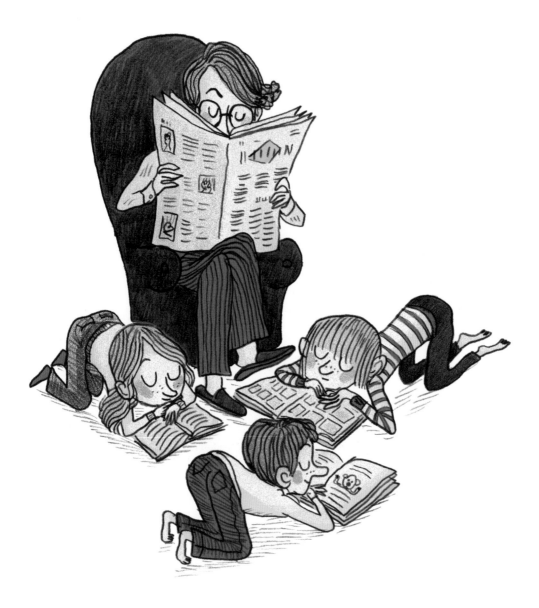

The Goosebump

The Chicken

The Bed Snuggler

The Fireside Cushion Hog

The Passenger
gets carried along

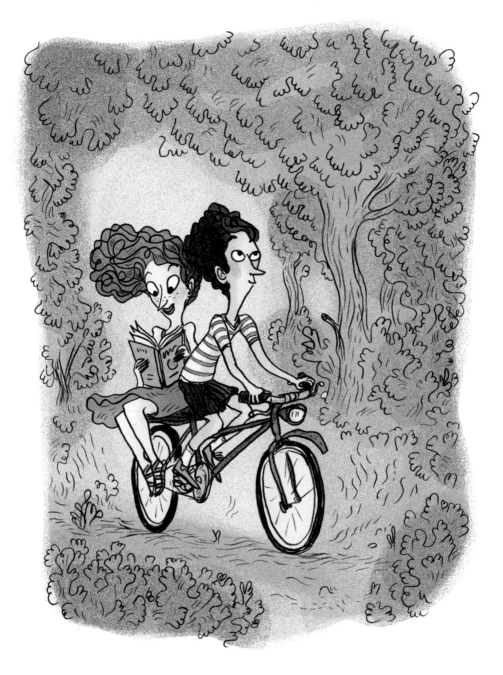

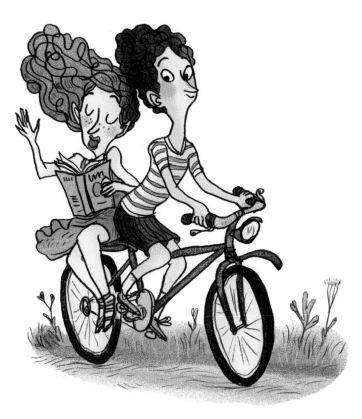

The Storyteller
gets carried away

The Water Lily
is immersed

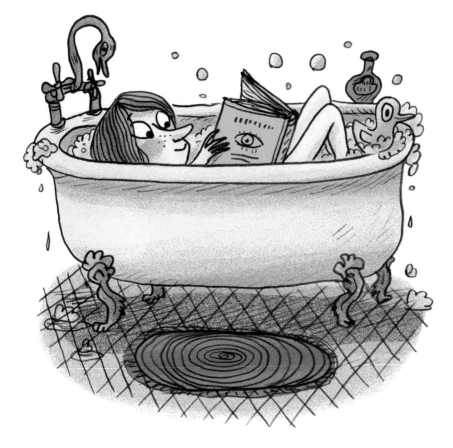

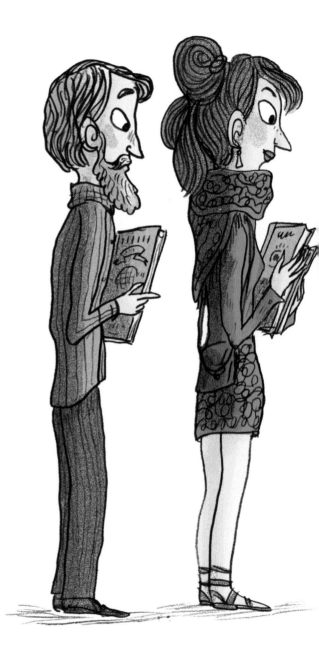

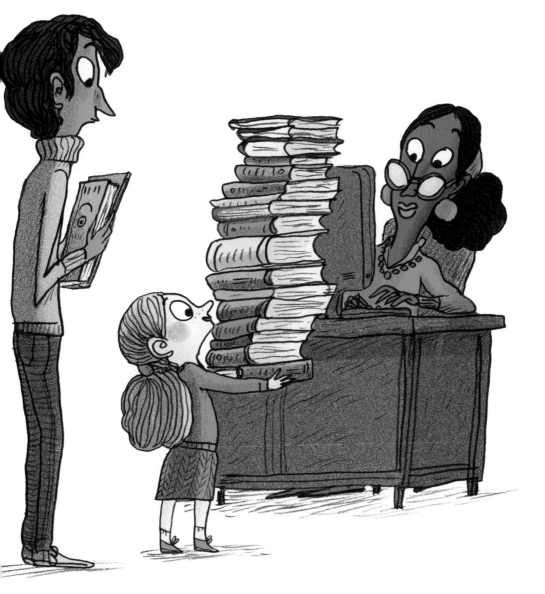

The Plunderer
ransacks the stacks

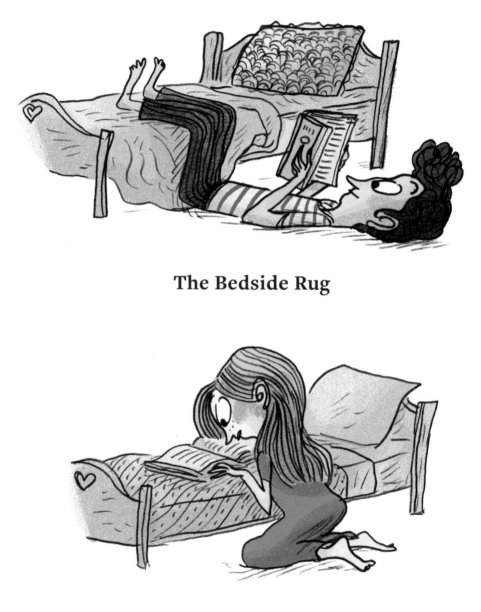

The Bedside Rug

The Devoted

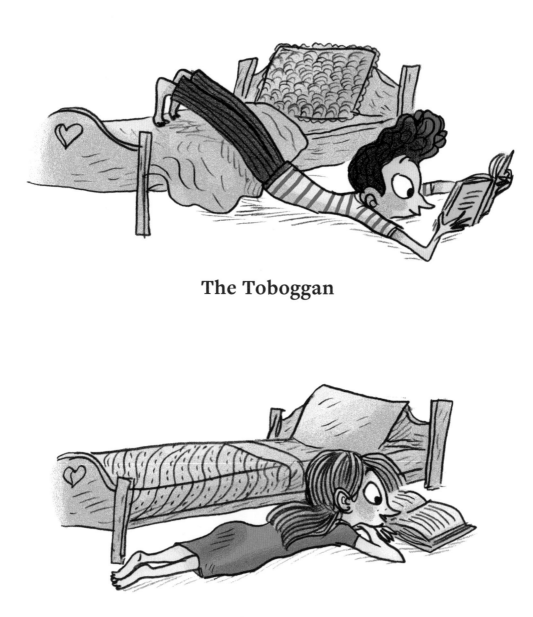

The Toboggan

The Mop

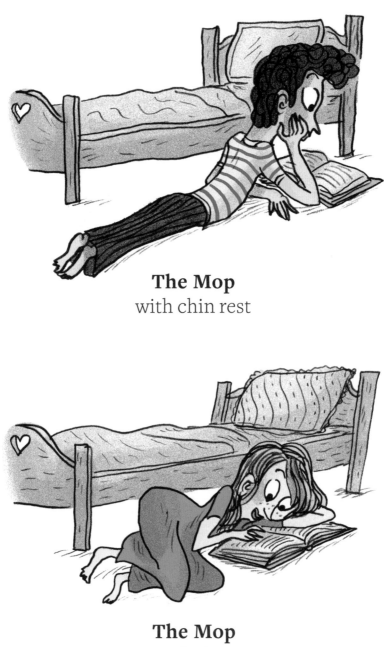

The Mop
with chin rest

The Mop
curled up

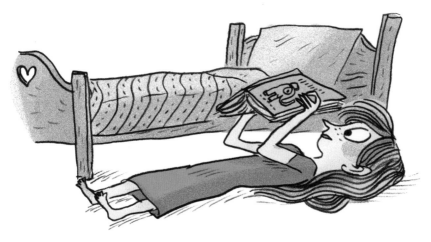

The Mop
supine

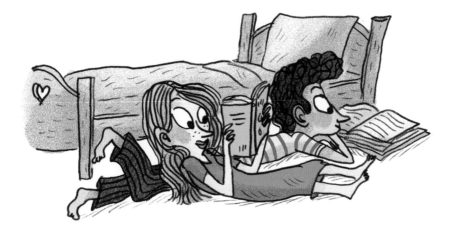

The Heap

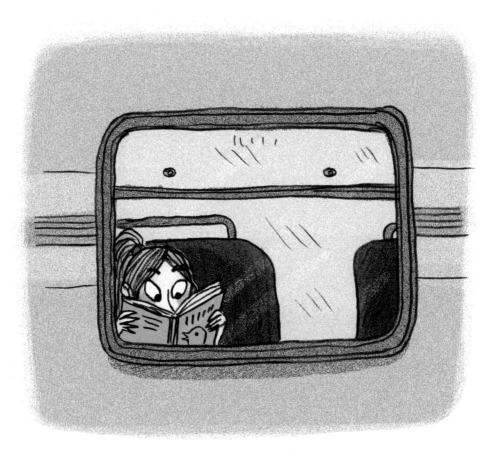

The Early Bird

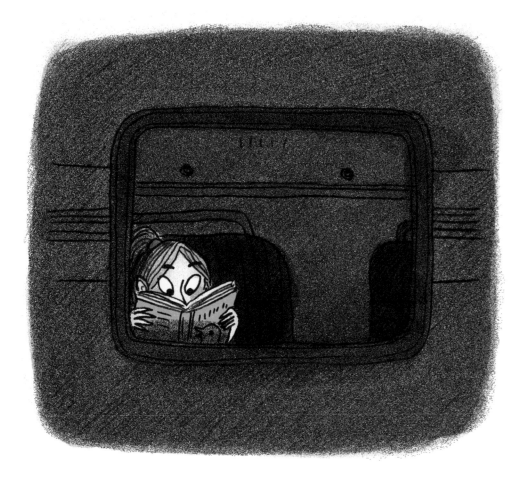

The Night Owl

The Snail
is in no hurry

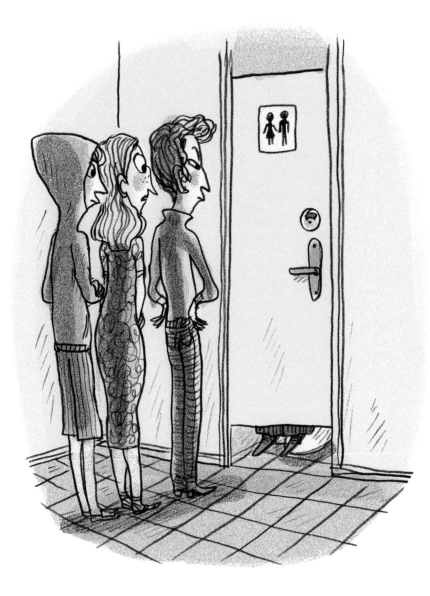

The Ghost
is most active at night

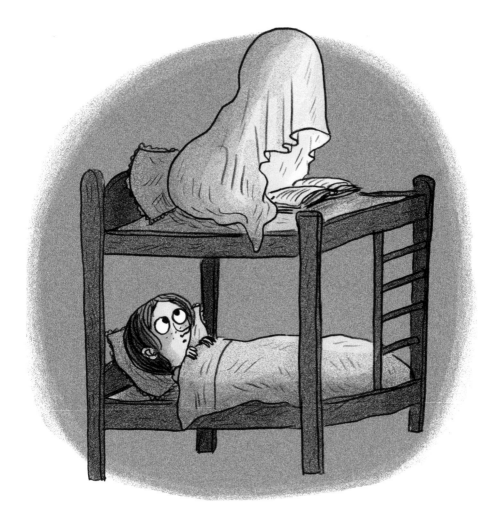

The Explorer
dreams of distant lands

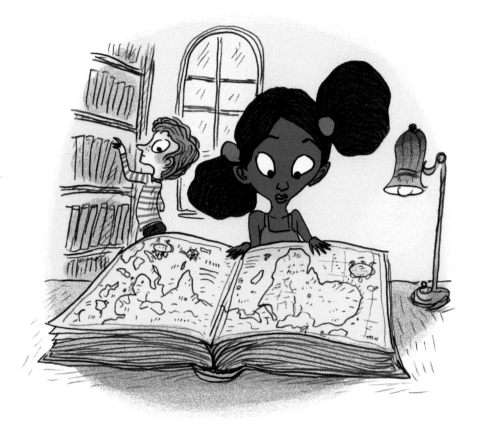

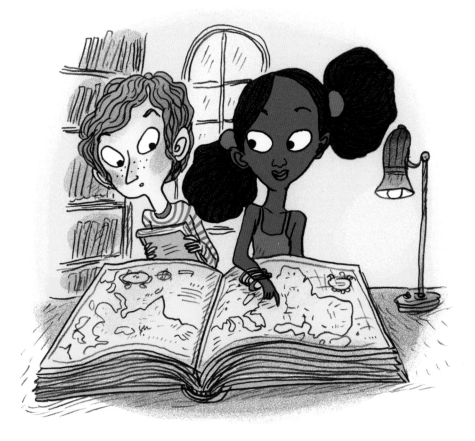

The Co-pilot
is at the ready

The Contortionist

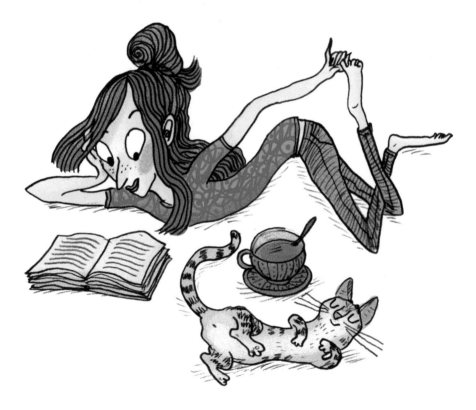

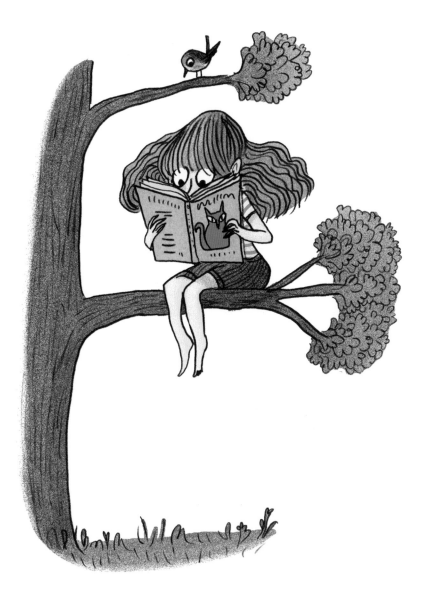

The Cat Up a Tree

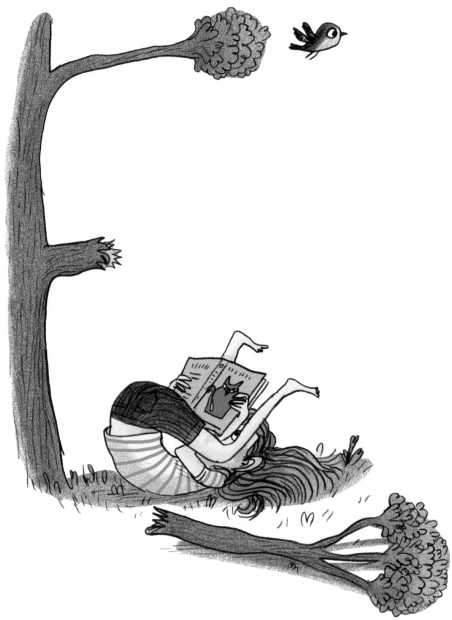

The Ripe Fruit

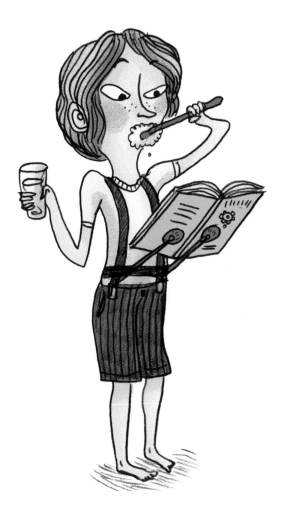

The Inventor

The Thinker

The Dreamer

The Skeptic

The Sentimental

The Snoop
sneaks a peek

The Barbarians
divide and conquer

The Specialist
digs in

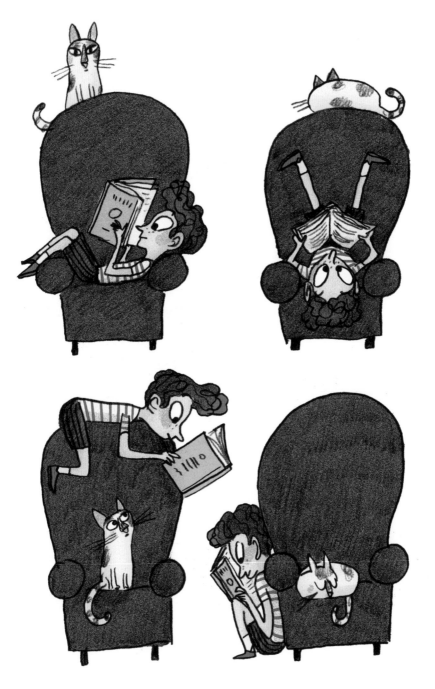

The Armchair Acrobat
cannot sit still

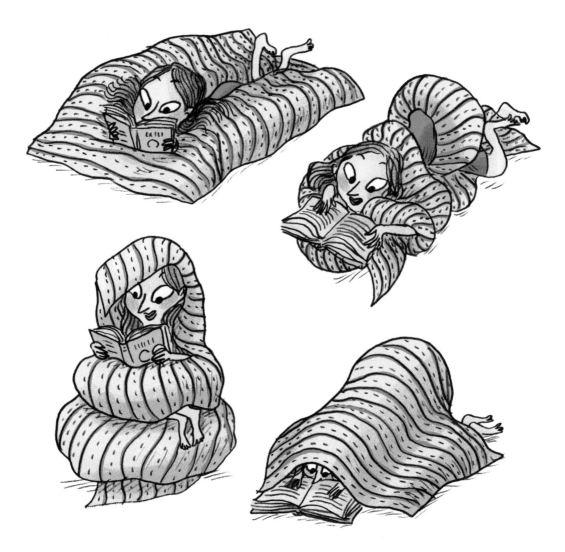

The Wiggle Worm
twists and turns

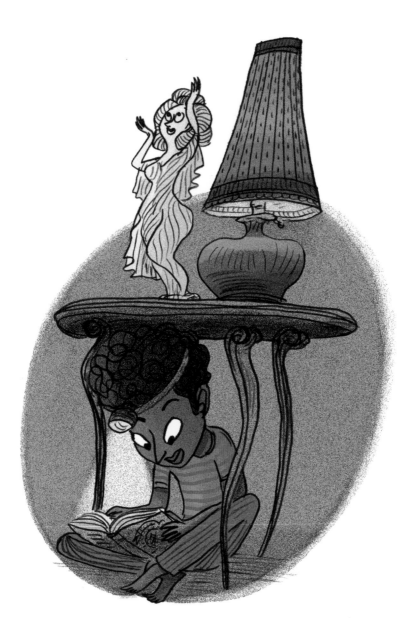

The Spelunker
goes underground

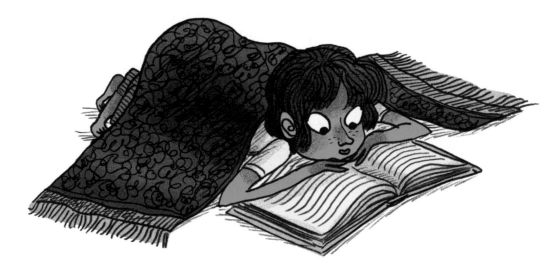

The Burrower
takes temporary cover

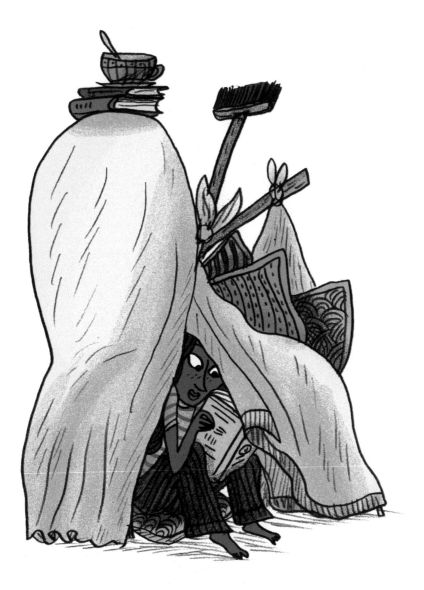

The Turtle
is always at home

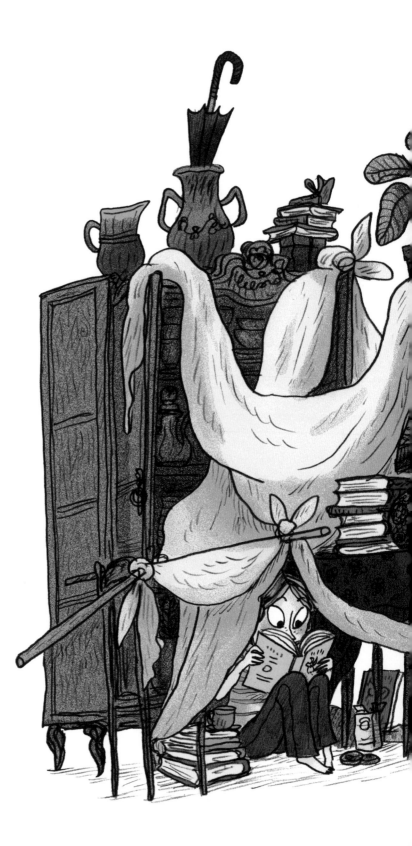

The Cathedral

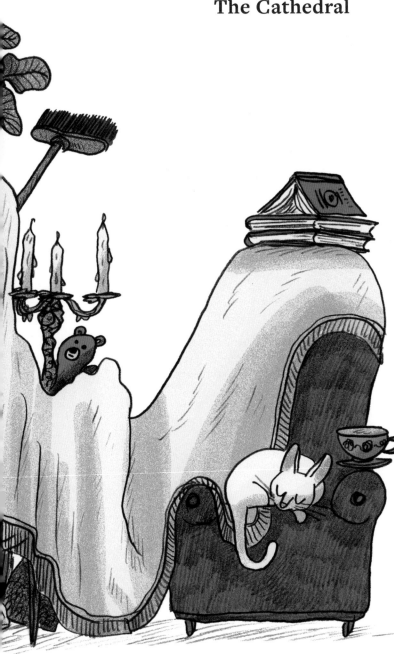

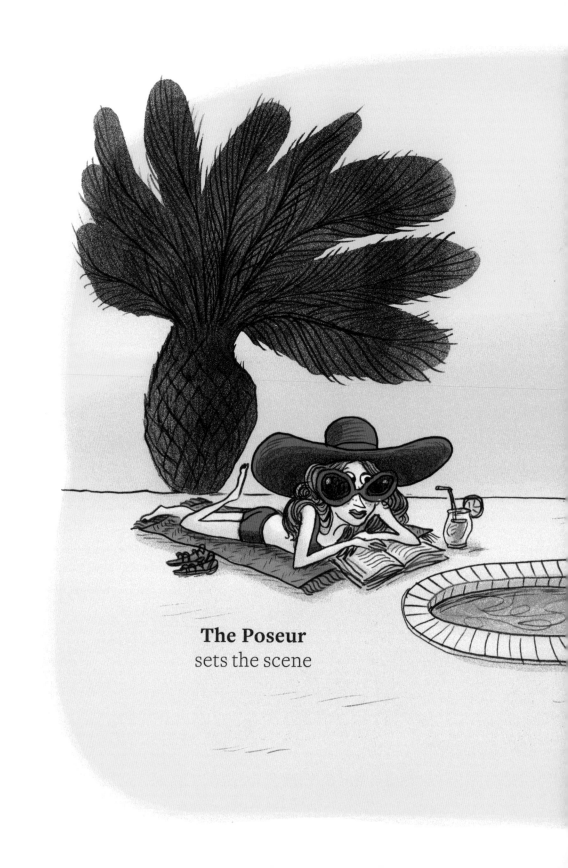

The Poseur
sets the scene

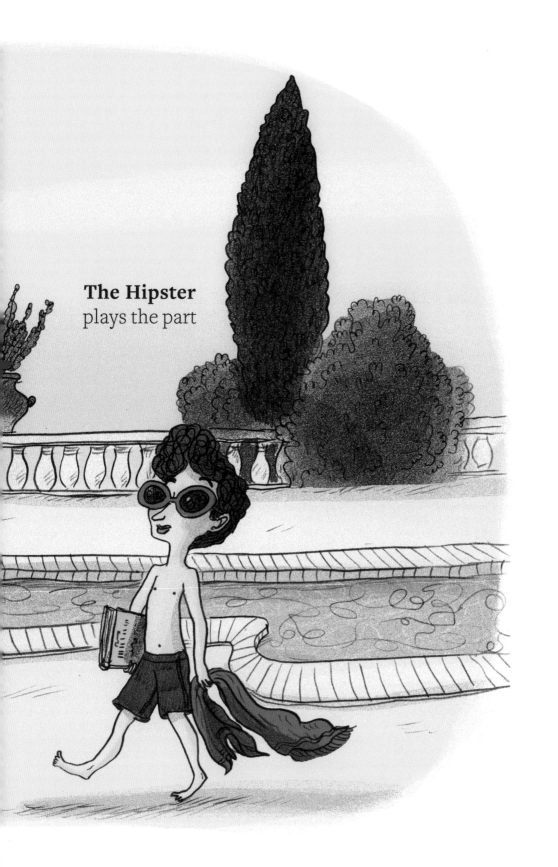

The Hipster
plays the part

The Mountain Goat
thrives at high altitude

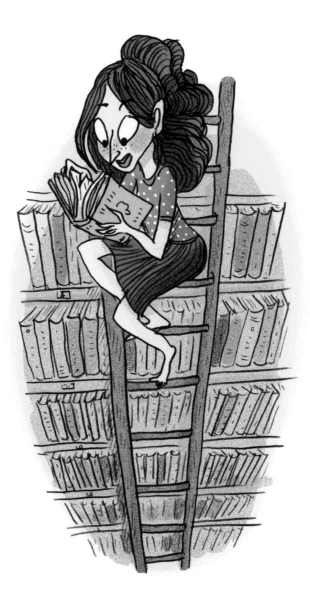

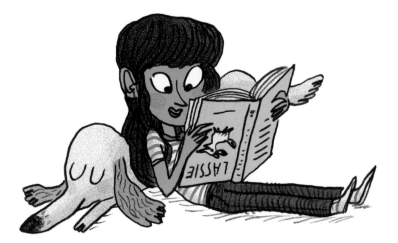

The Cuddler
loses focus

The Fortress
commands peace

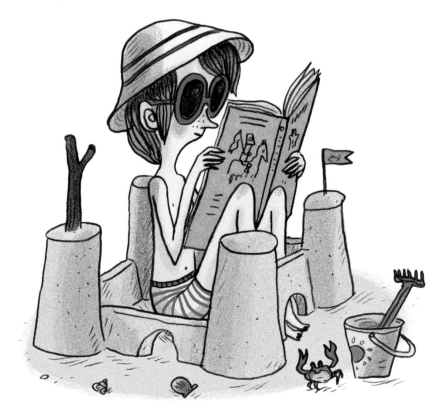

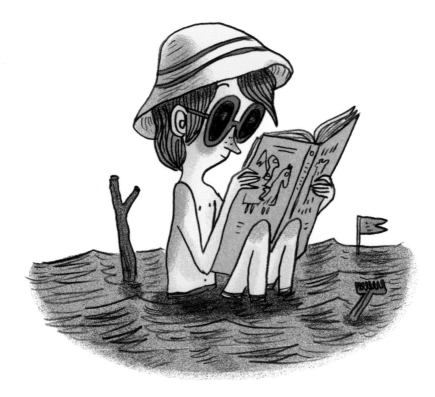

The Sinking Ship
never bails

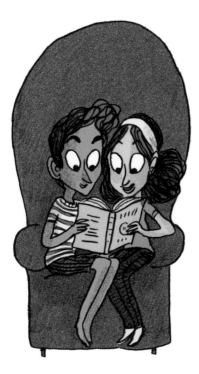

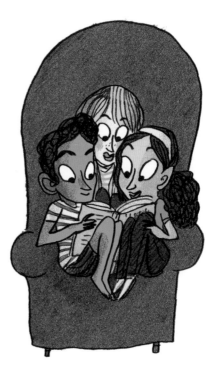

The Duo The Trio

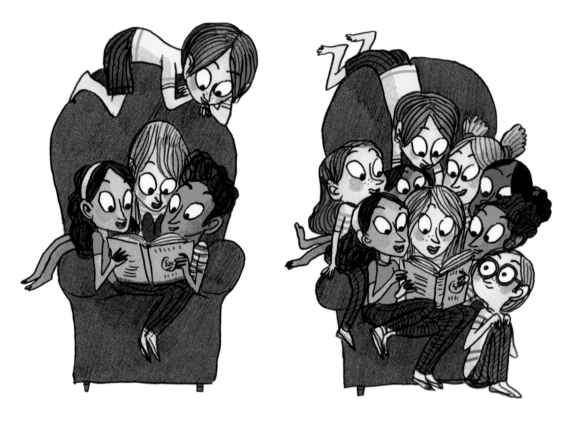

The Quartet The Anthill

The Pirate
finds buried treasure

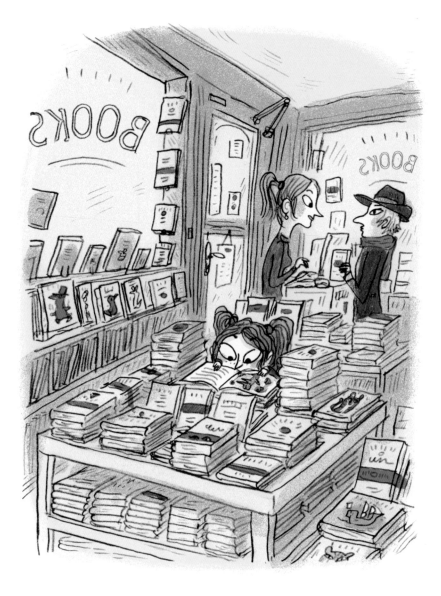

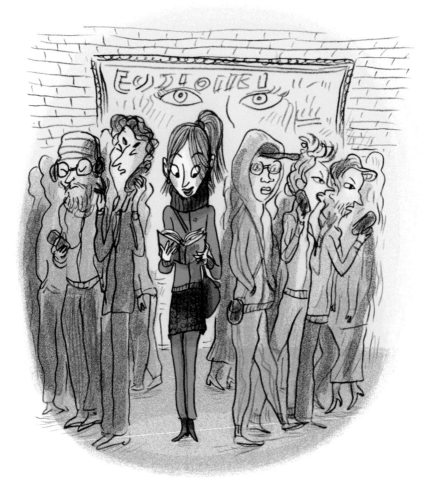

The Desert Island
is a world away

The Voracious

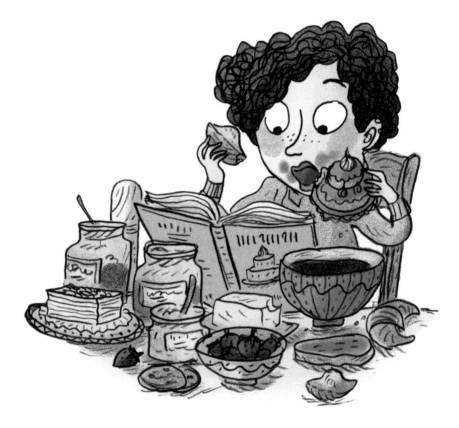

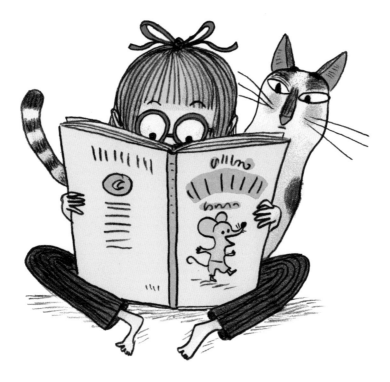

The Usurper

The Baggage

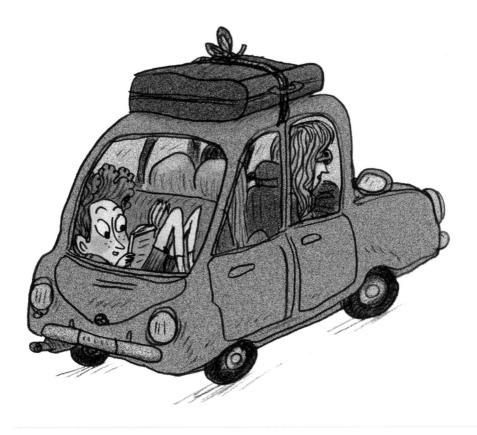

The Time-Honored
Tree Leaner

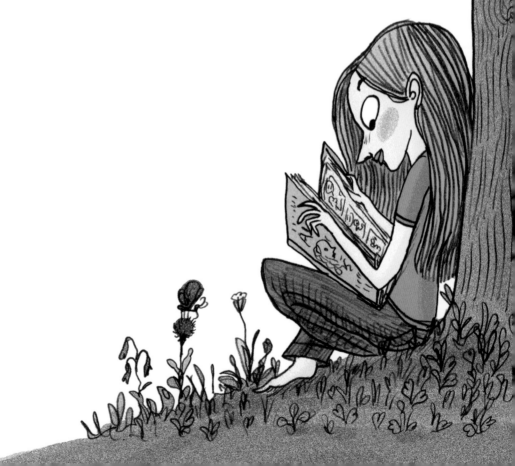

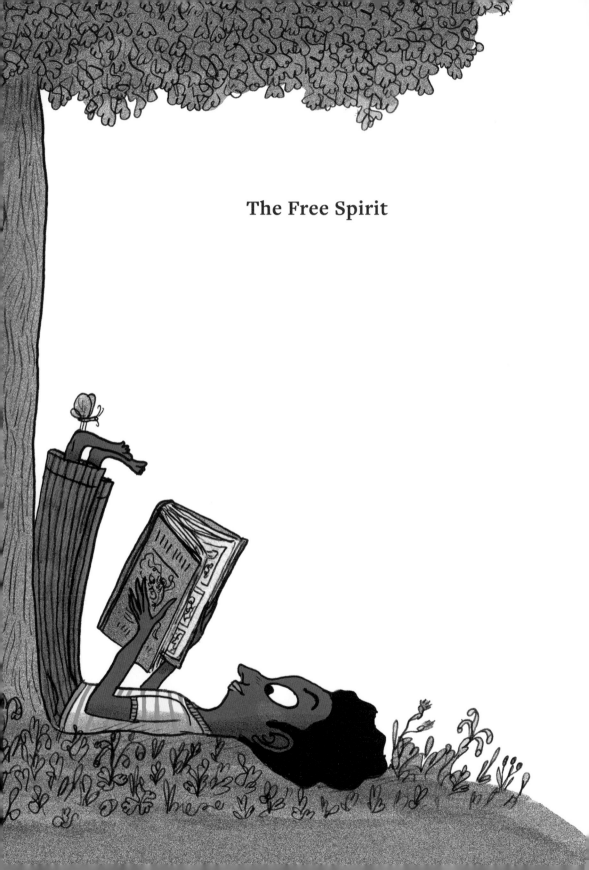

The Free Spirit

The Vine

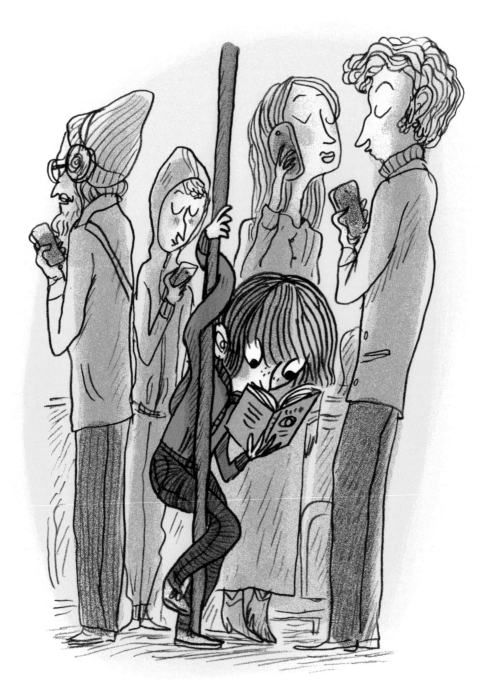

The Traveler
is indifferent to delays

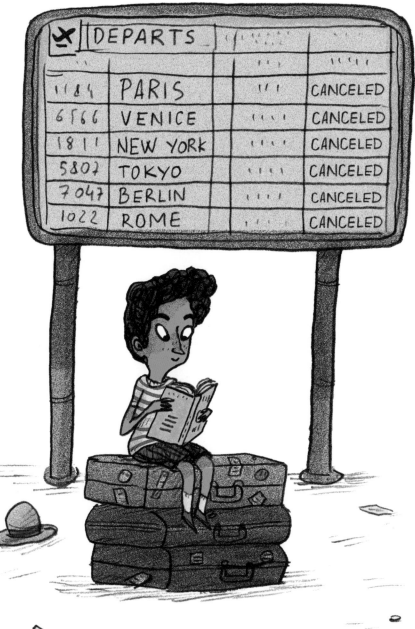

The Bed Bug
triumphs over adversity

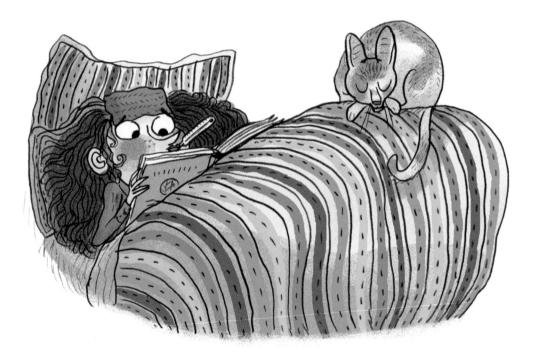

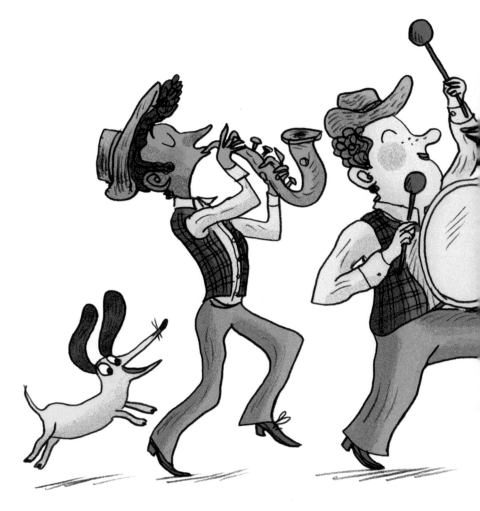

The Heroes
persevere

The Imaginative
transform the world

101 Ways to Read a Book
Text copyright © 2022 Timothée de Fombelle
Illustrations copyright © 2022 Benjamin Chaud

This edition published in 2023 by Red Comet Press LLC, Brooklyn, NY
Translated by Karin Snelson & Angus Yuen-Killick

Original French edition published as *101 façons de lire tout le temps* © 2022 Gallimard Jeunesse

Library of Congress Control Number: 2023930540

ISBN (HB): 978-1-63655-082-4
ISBN (EBOOK): 978-1-63655-083-1

23 24 25 26 27 TLF 10 9 8 7 6 5 4 3 2 1

First Edition
Manufactured in China

RedCometPress.com